ART MOVEMENTS SERIES
RENAISSANCE

Copyright © 2019 Vivid Publishers / Chinthaka Herath
Illustrated by Chinthaka Herath
Design & layout by Intense Media

All rights reserved. No part of this publication may be reproduced, distributed or transmitted in any form or by any means including photocopying, recording or other electronic or mechanical methods, without the prior written permission of the Publisher/ Chinthaka Herath.

ISBN-13: 9781098988685

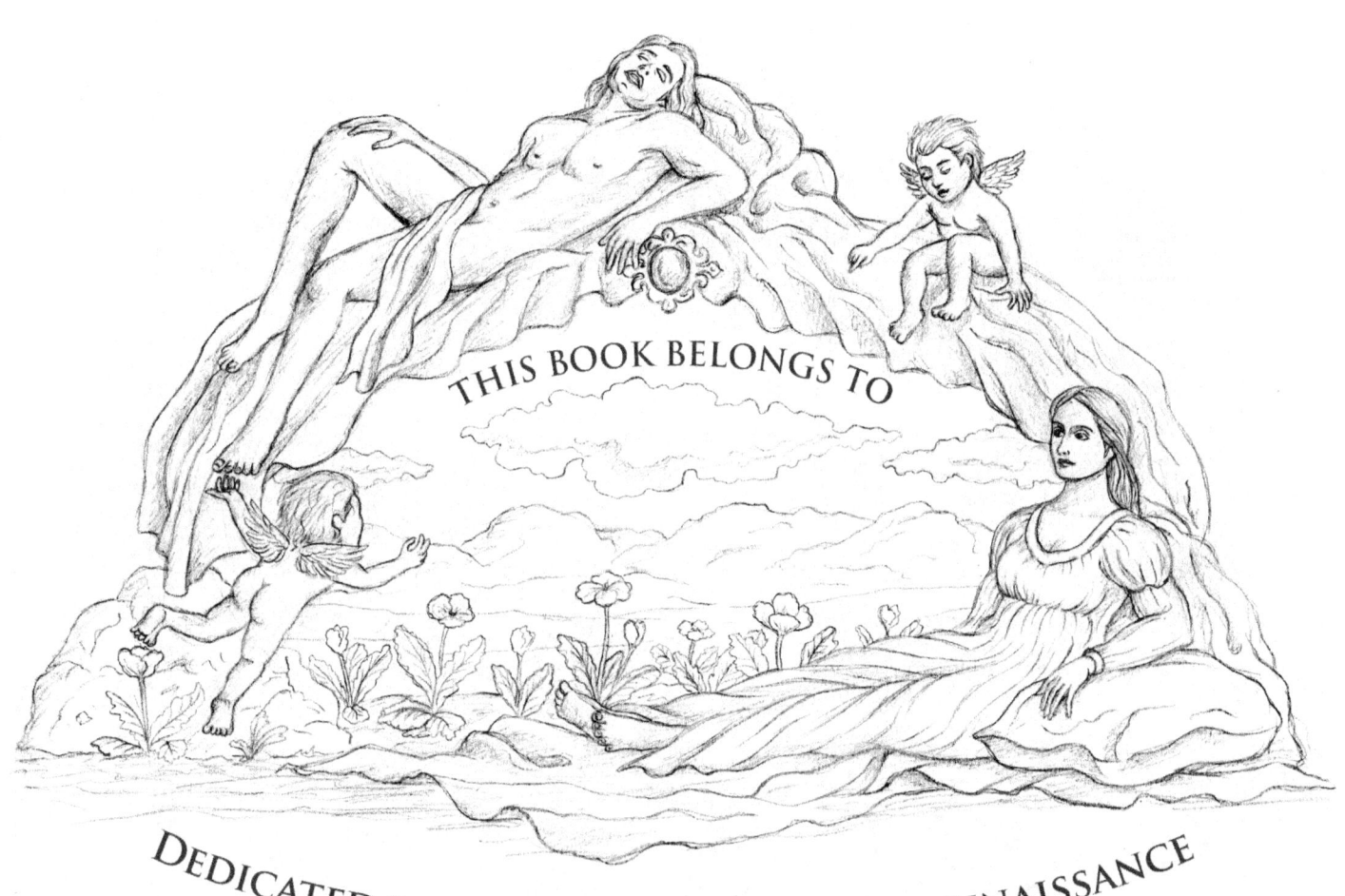

INTRODUCTION

Thank you for purchasing 'Renaissance'! This book includes 24 plus illustrations drawn by Chinthaka Herath. These drawings are based on the masterpieces of the Renaissance Art Movement, created after going through numerous works of art from this period for inspiration.

Join us in this celebration of the vision & artistry, which was a rebirth of the ideals of early Greek & Roman art. We hope you find inspiration in coloring these pages of art and bringing them to life.

All art is hand drawn & some shading is included as a guide to add shadowing & lighting.

You can use any coloring medium from pencils to markers as long as they have a fine tip.

A note on the use of markers: Even though the illustrations are printed one per page, to give additional protection please place a thick paper or cardboard beneath the page you are coloring so that the ink will not bleed through to the next page.

Subscribe at our website to get a FREE 10 Page PDF Sampler 'Fantasy Art Adult Coloring Collection' featuring pages from our three adult coloring books August Reverie 1, 2 and Saga: Fire & Water! Plus, news on discounts, free pages, contests and more!

 www.vividpublishers.com

We would love to see your completed art. You can reach us at:

 fb.com/VividPublishers

 @VividPublishers

Also, we welcome you to join our Facebook group to share your art, see other colorists' art, enter exciting contests plus more!

 fb.com/groups/VividPublishers

Thank you for your continued support and interest in our adult coloring books. We hope you enjoy coloring the pages as much as we did creating them. Happy Coloring!

CONTENTS

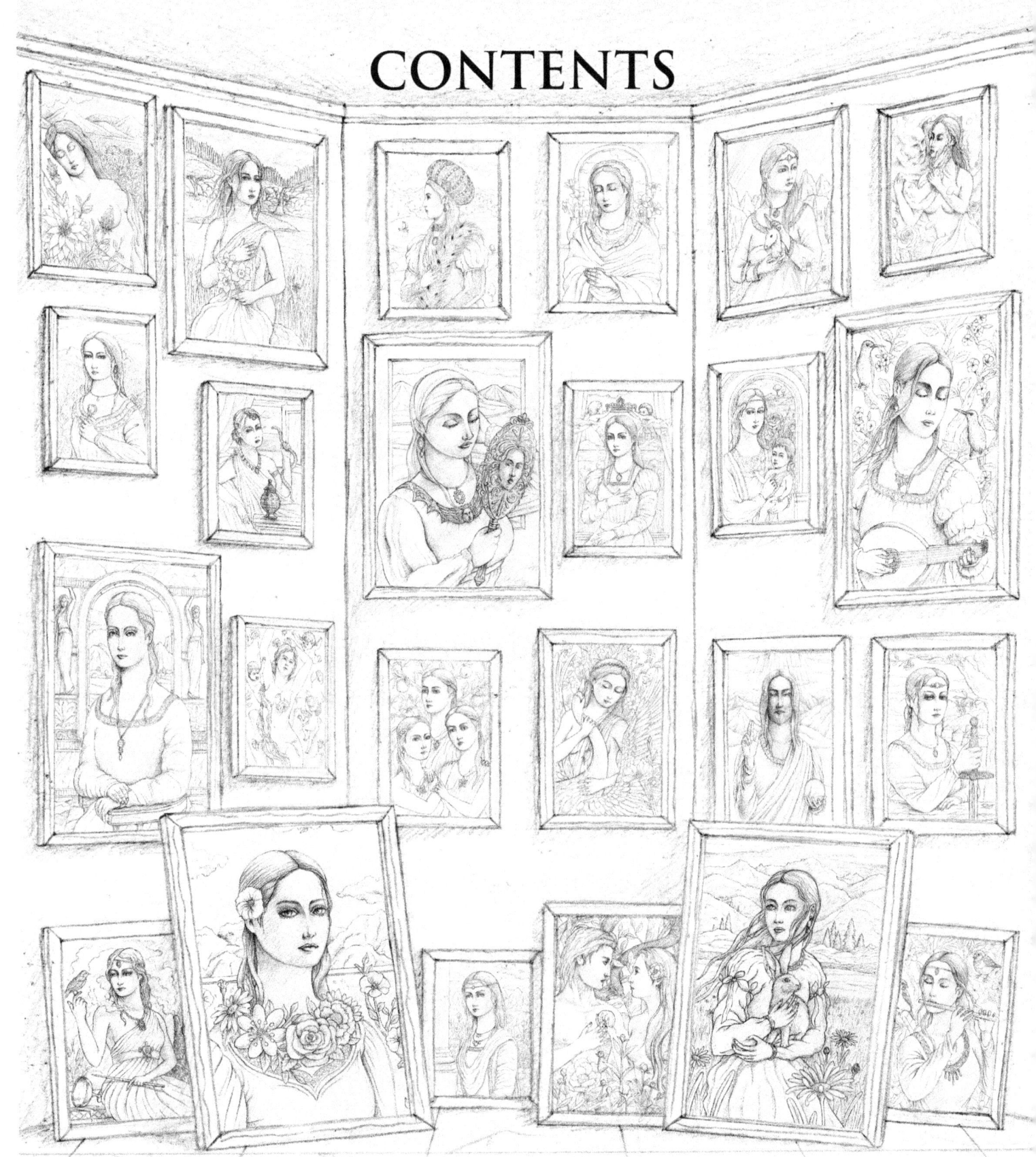

1) Sleeping Venus 3) Echo 5) Marchioness 7) Prayers
9) Lady with a Unicorn 11) Jupiter and Io 13) Girl with a Rose
15) Death of Cleopatra 17) Looking in the Mirror
19) Princess and Cherubs 21) Mother and Child
23) Lady Playing the Lute 25) Tributo Trinity 27) Birth of Venus
29) Three Graces 31) Leda and the Swan 33) Salvator Mundi
35) Judith 37) Circé and Picus 39) Flora 41) La Belle Ferronnière
43) Adam and Eve 45) Lady with a Rabbit 47) Lady Playing the Flute

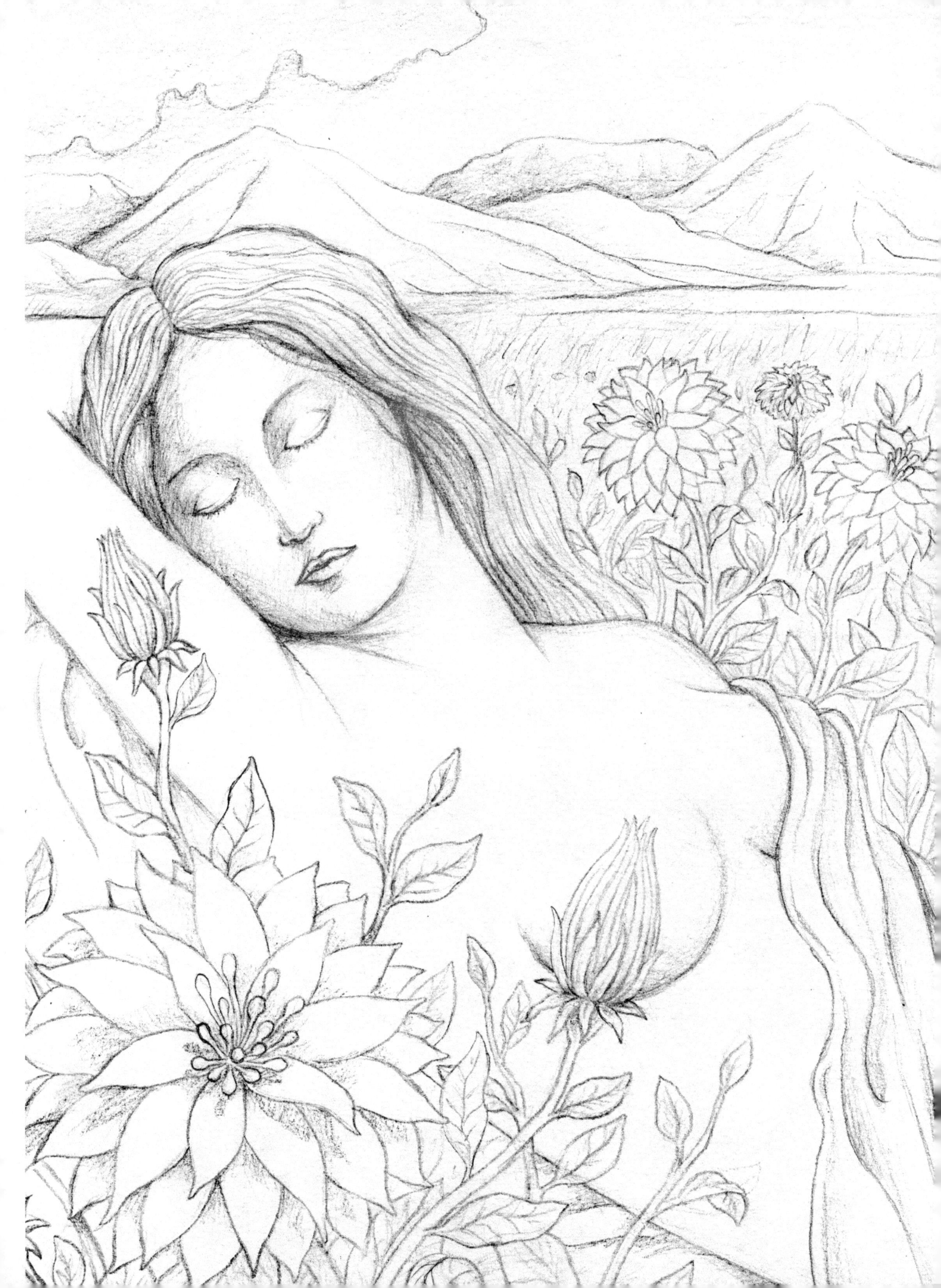

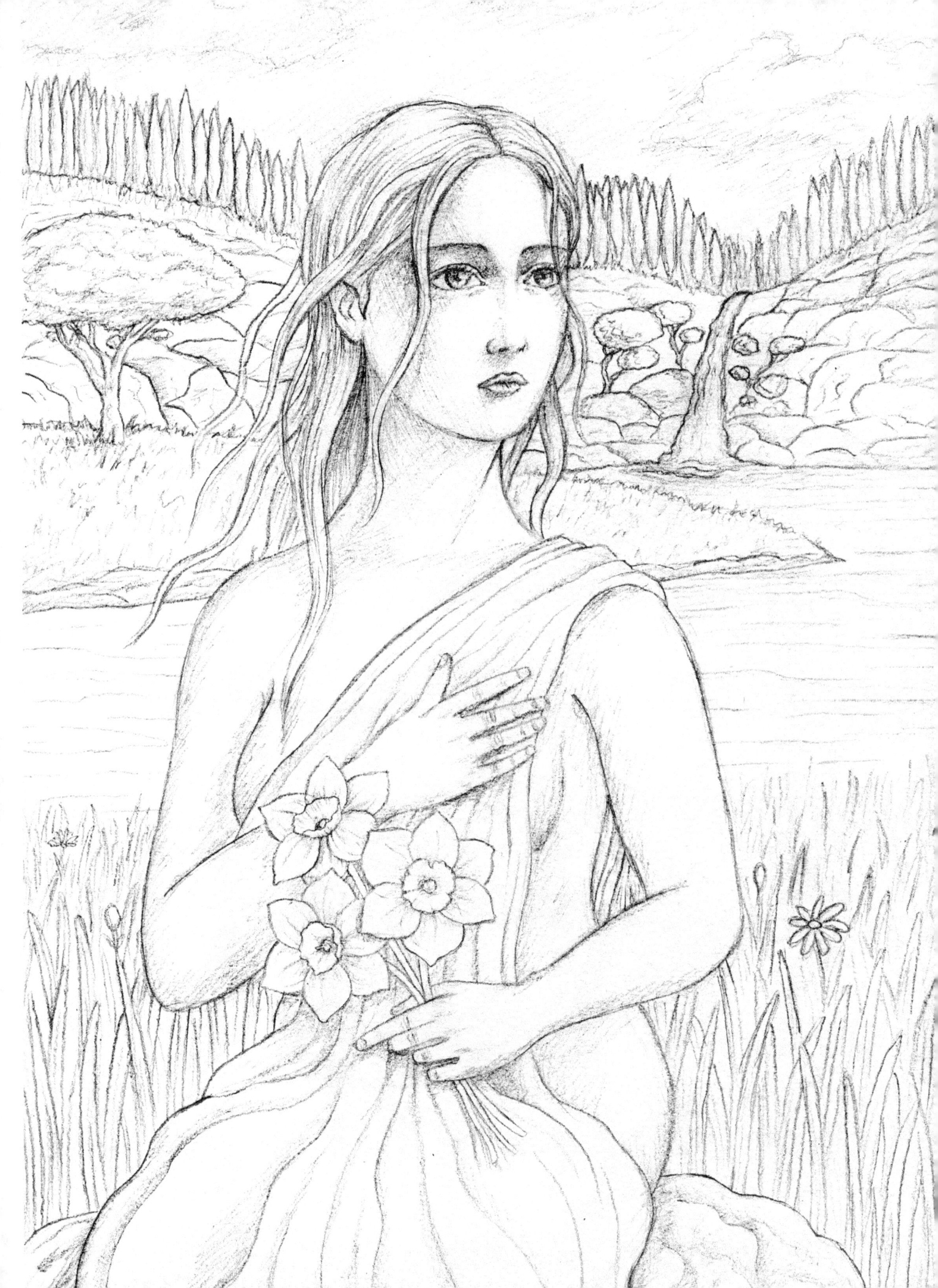

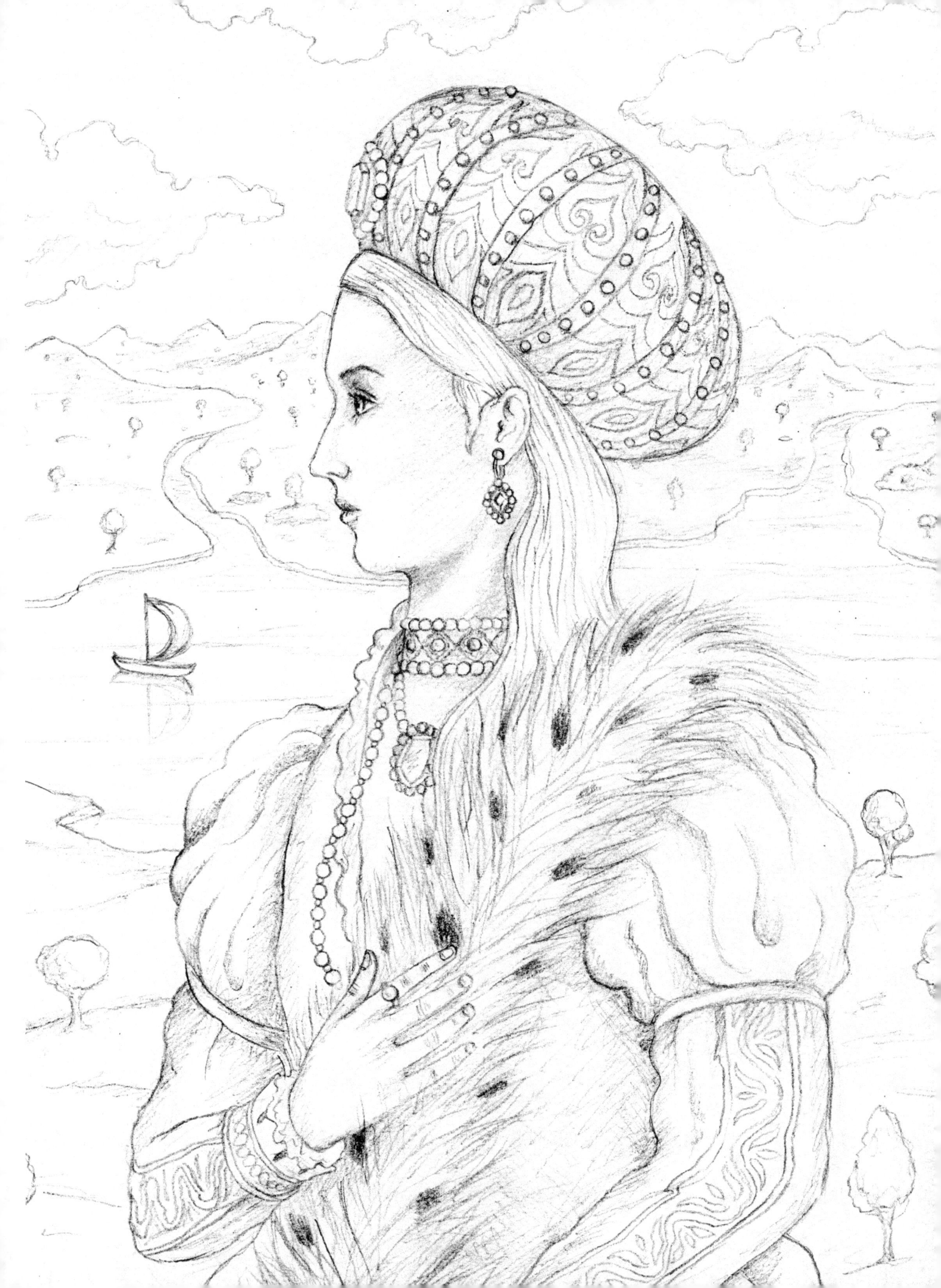

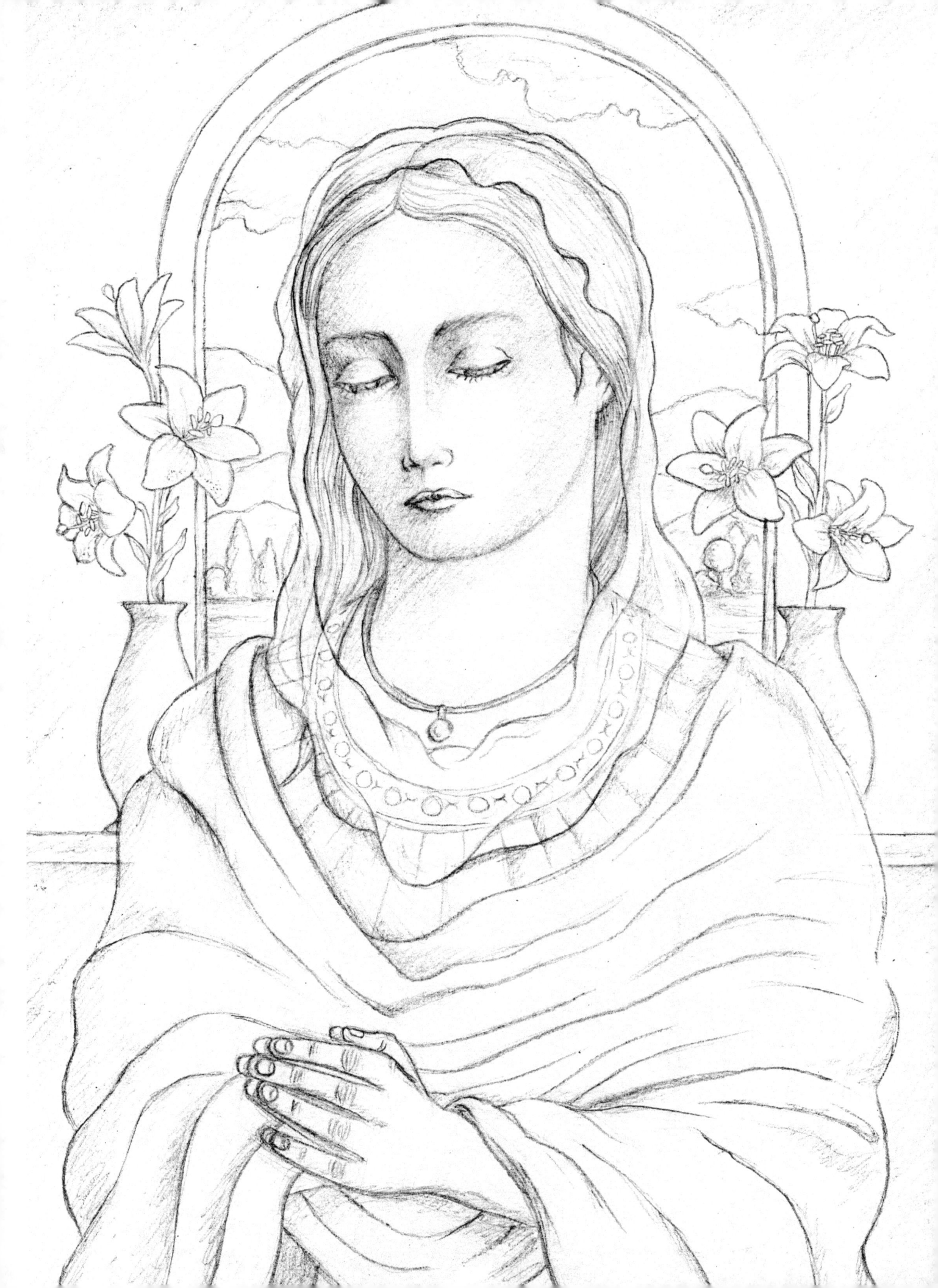

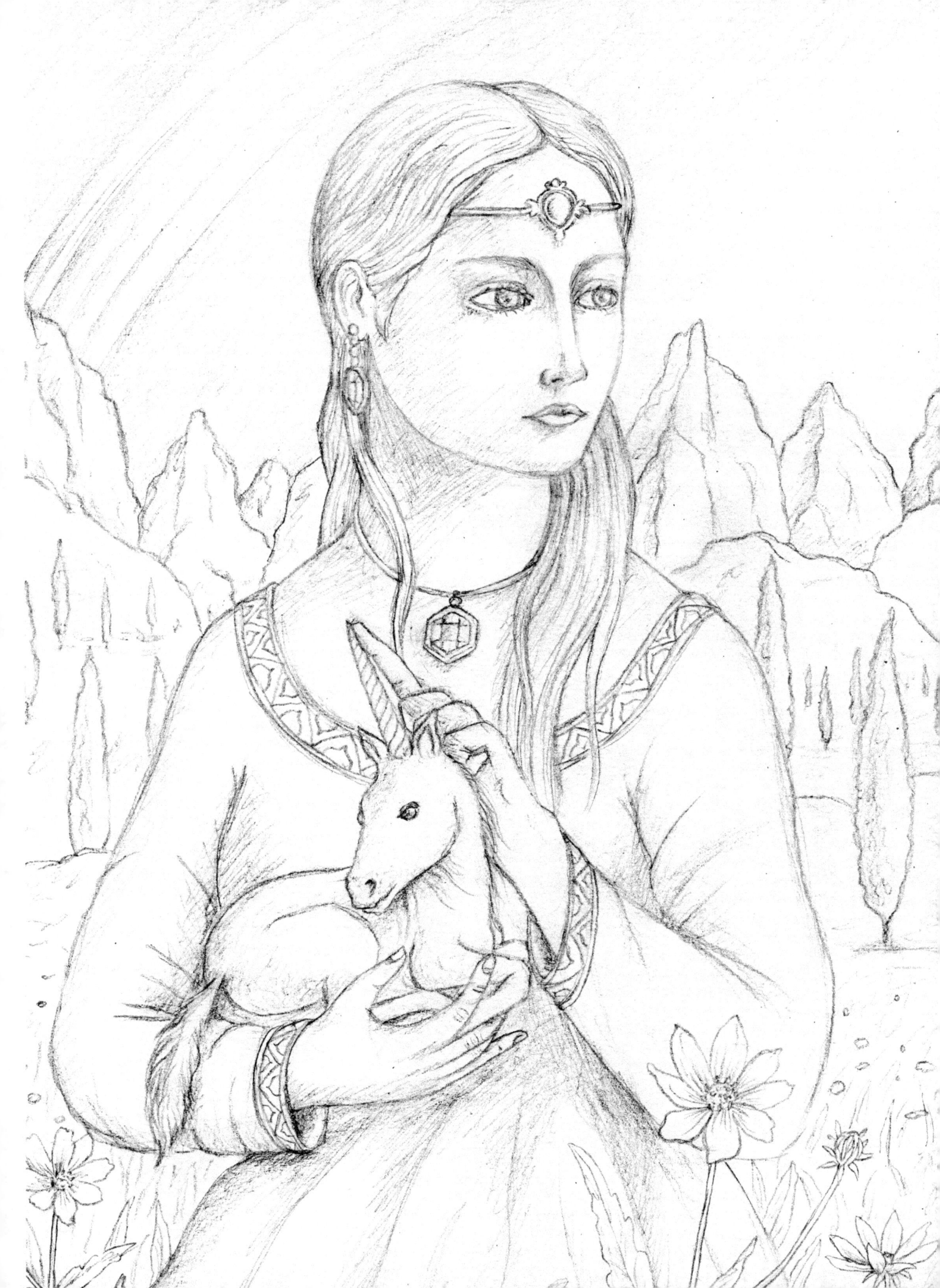

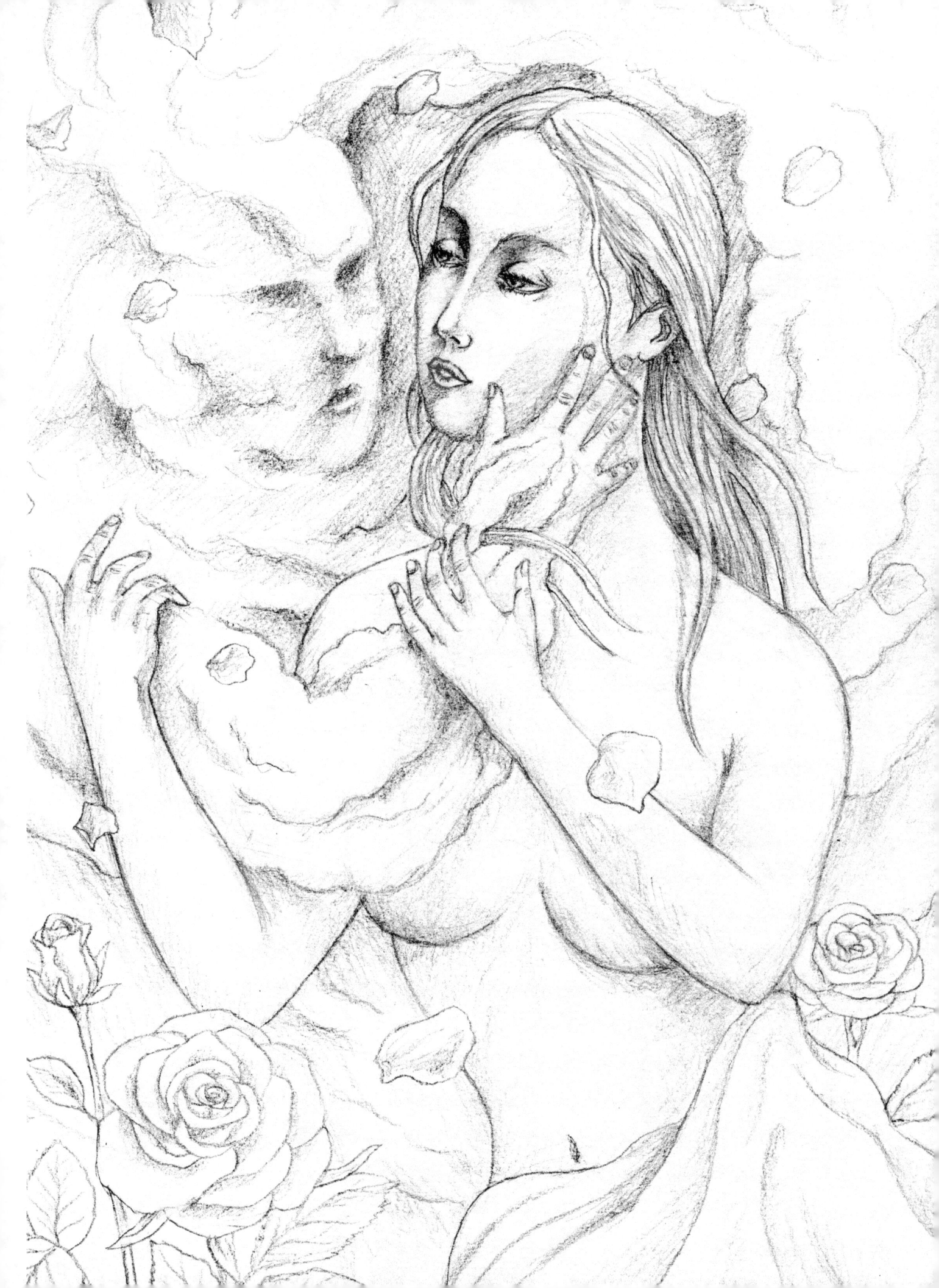

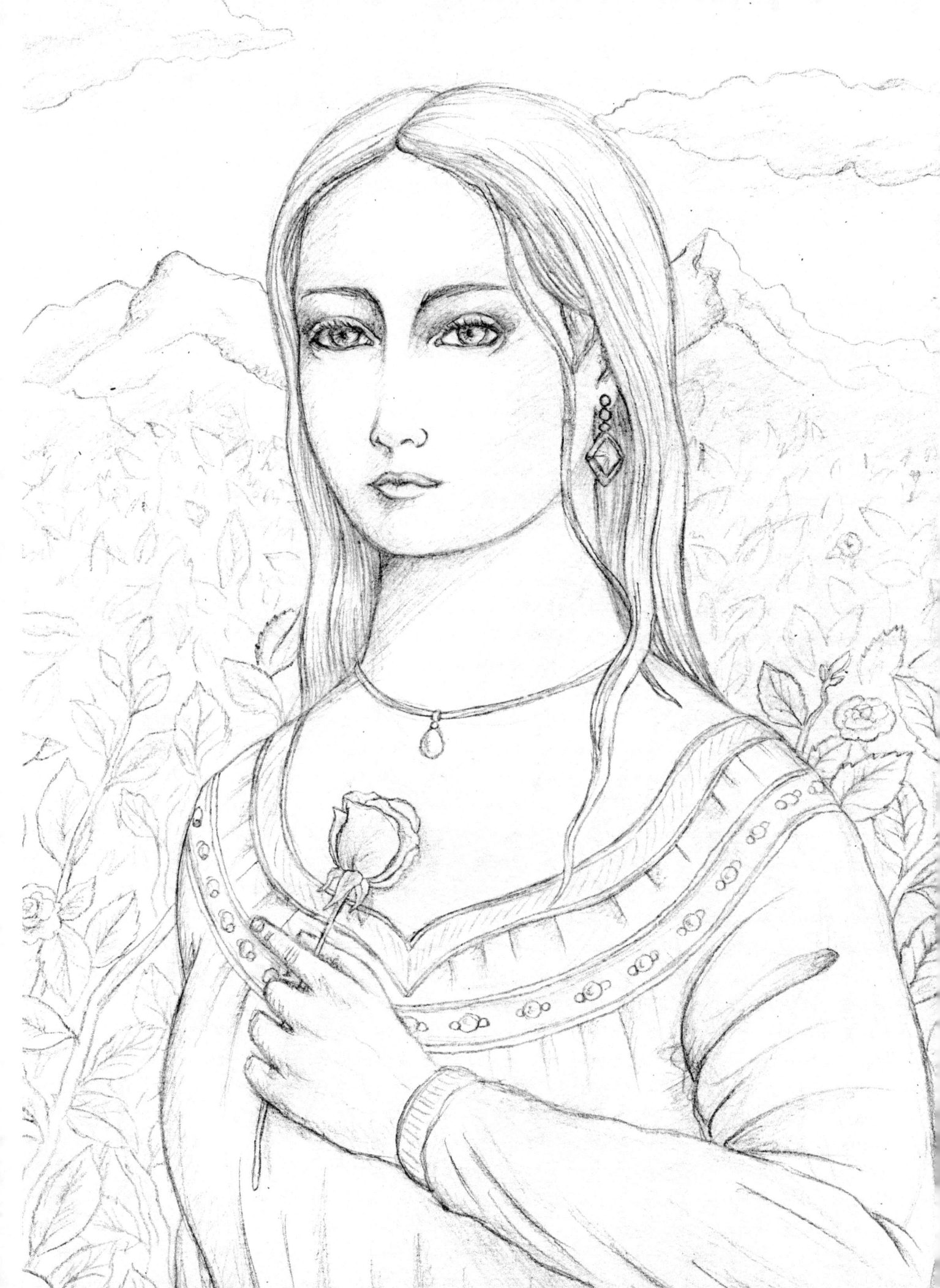

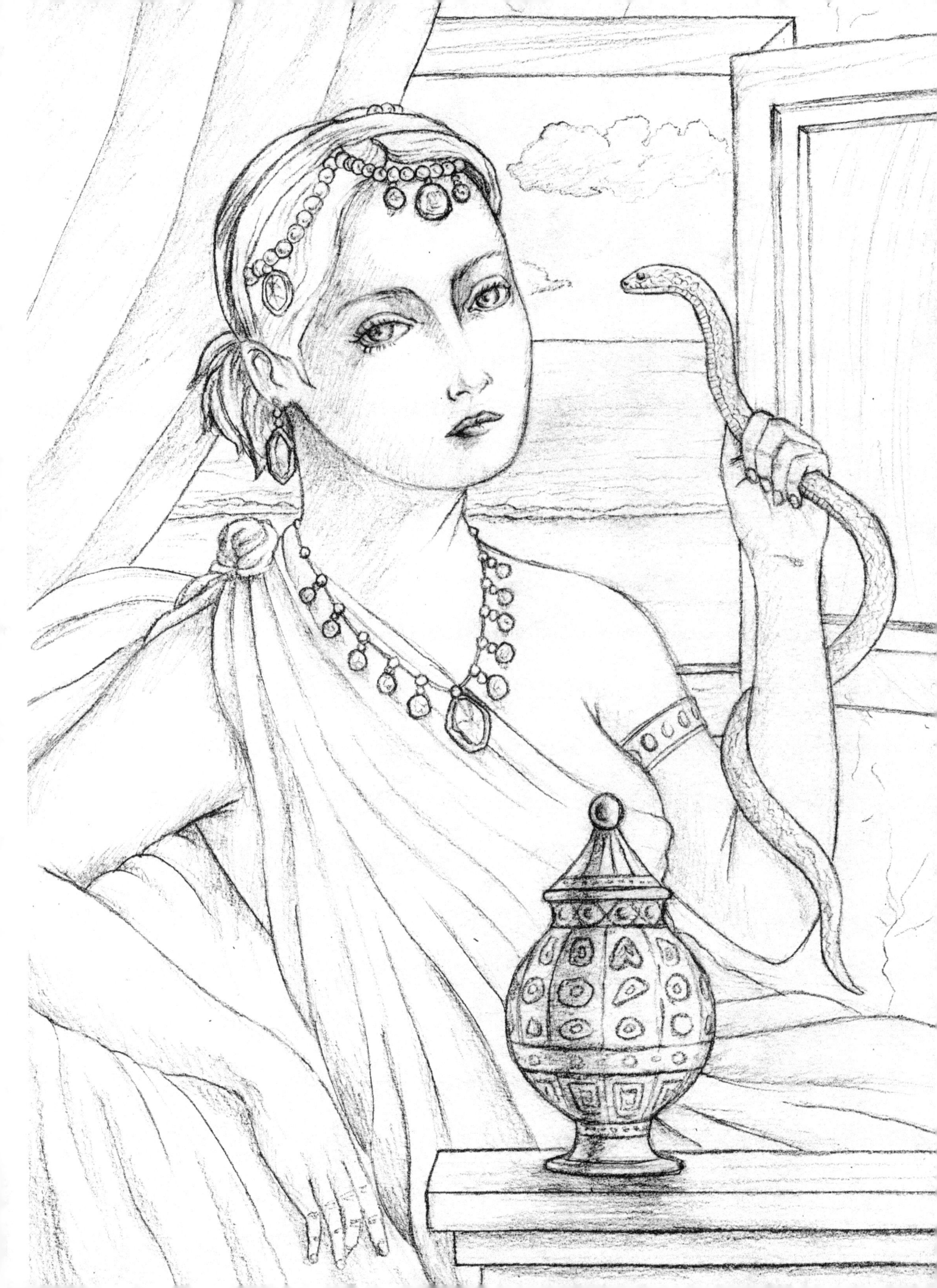

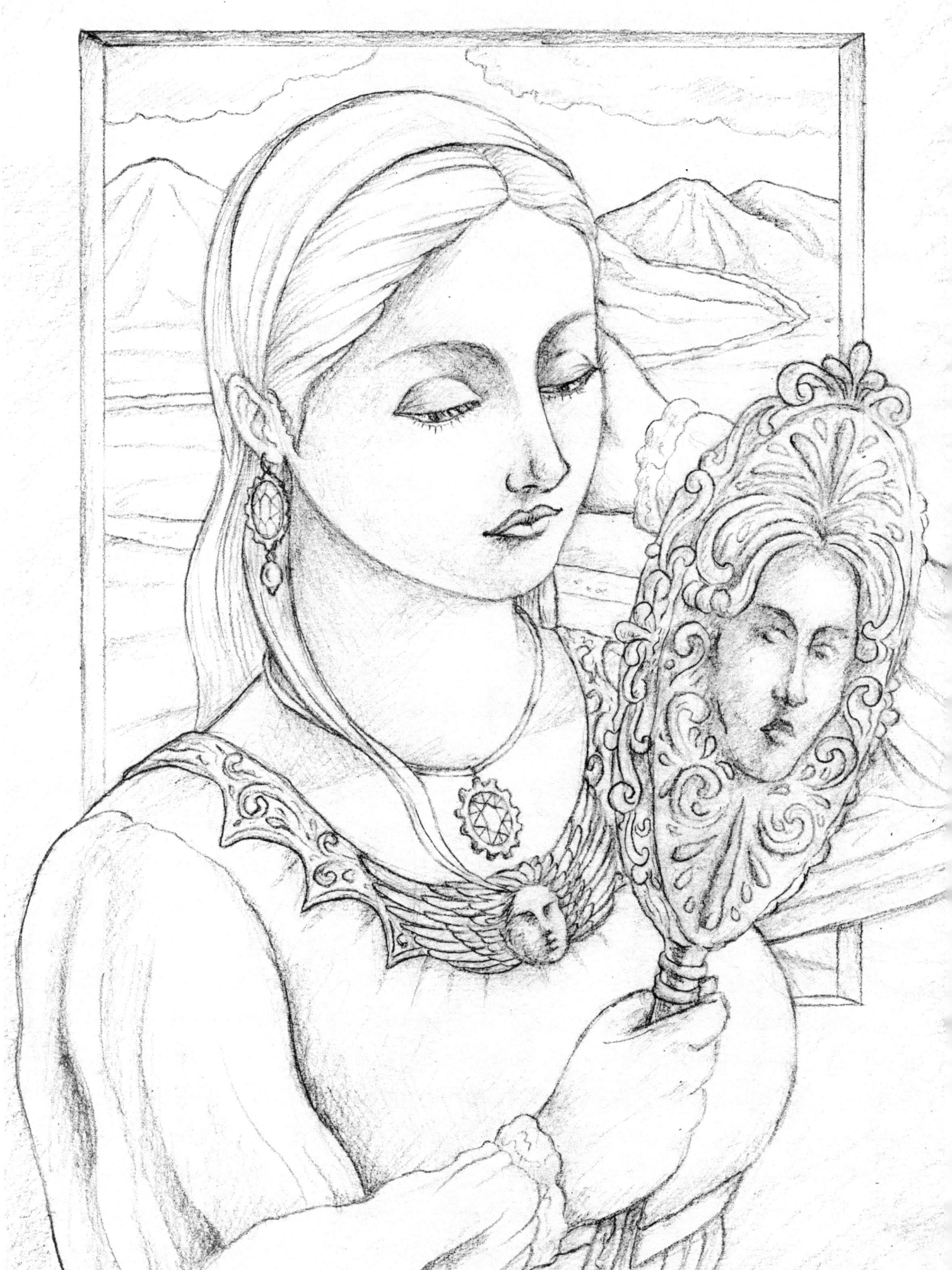

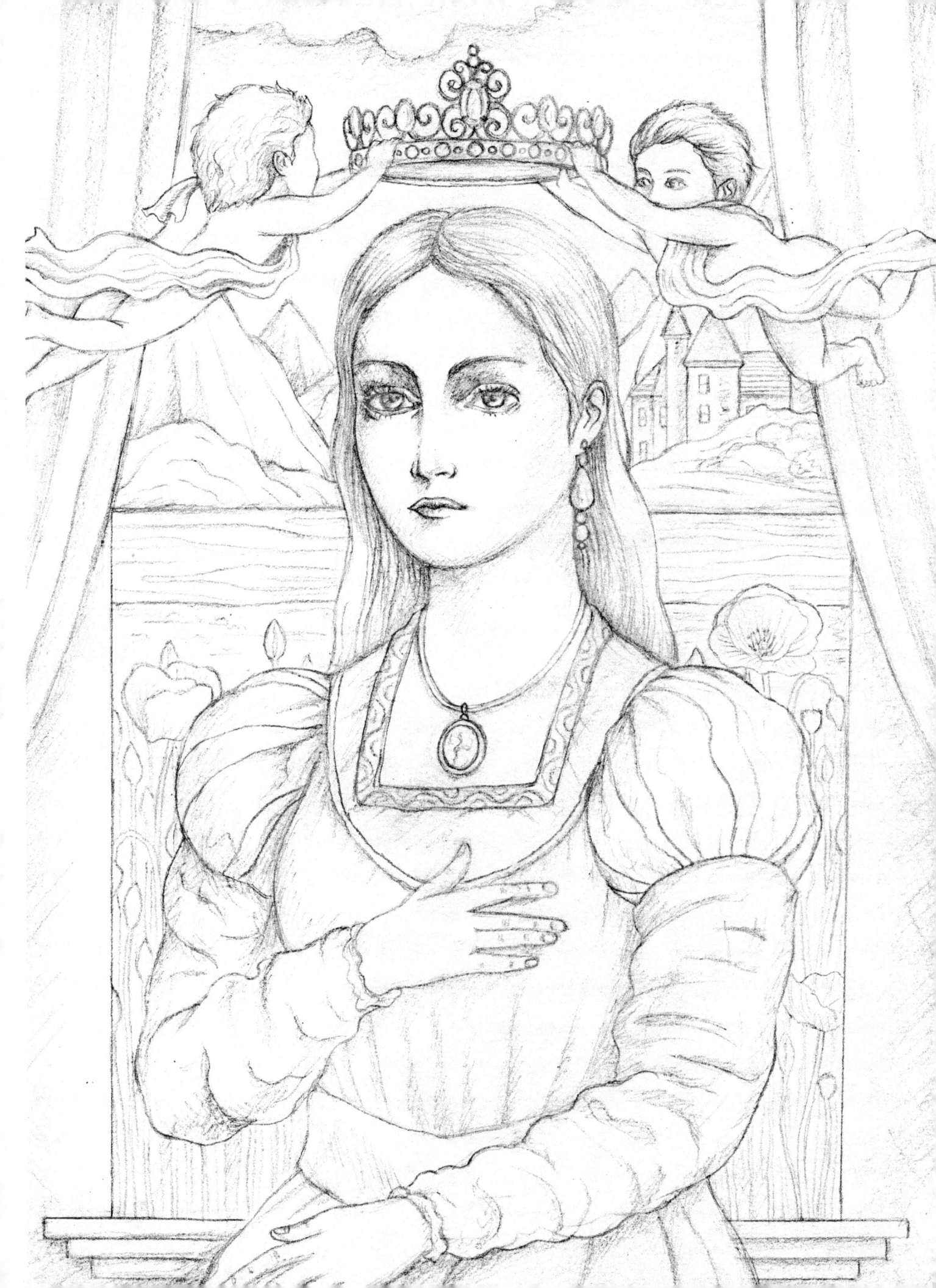

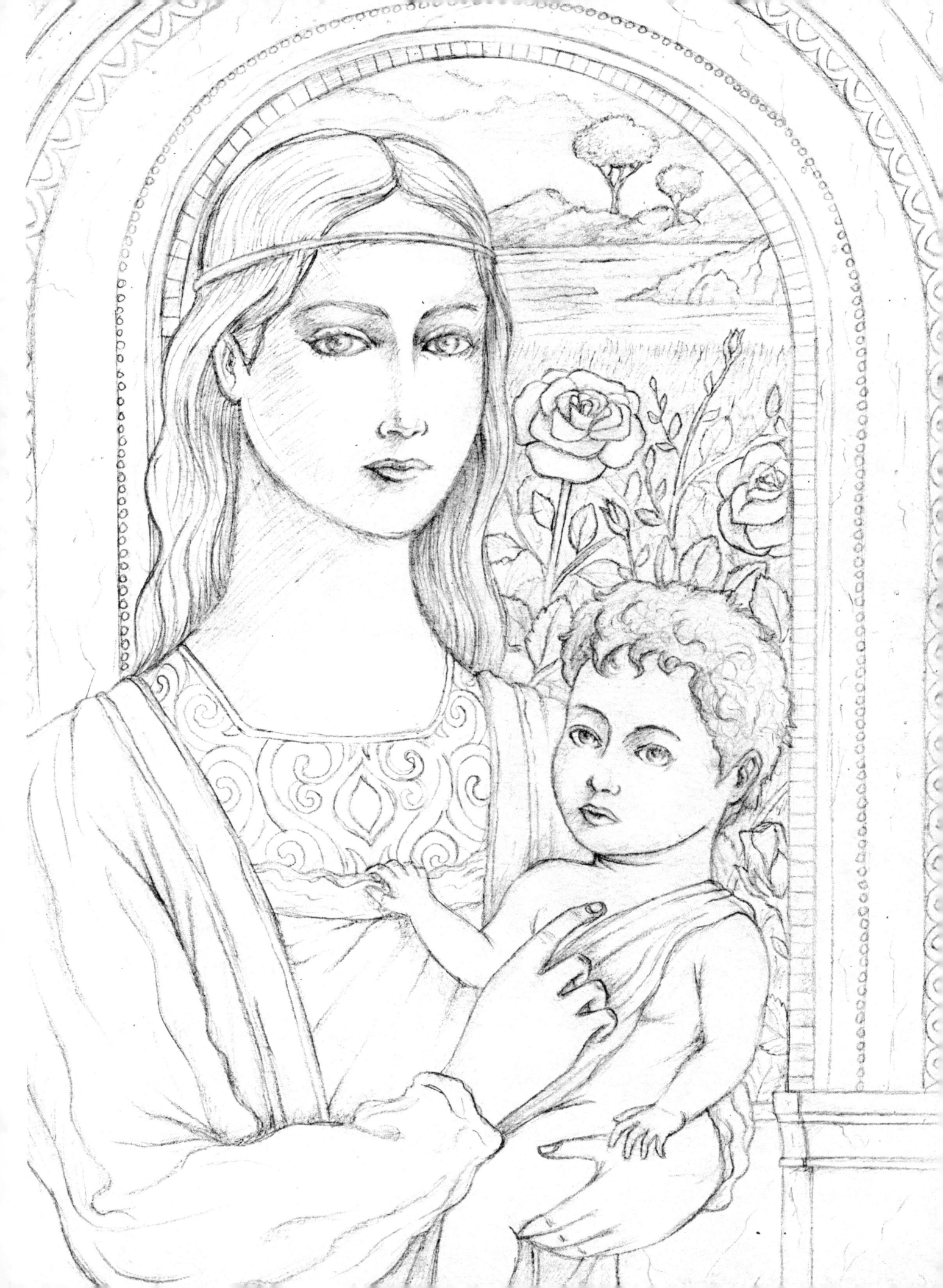

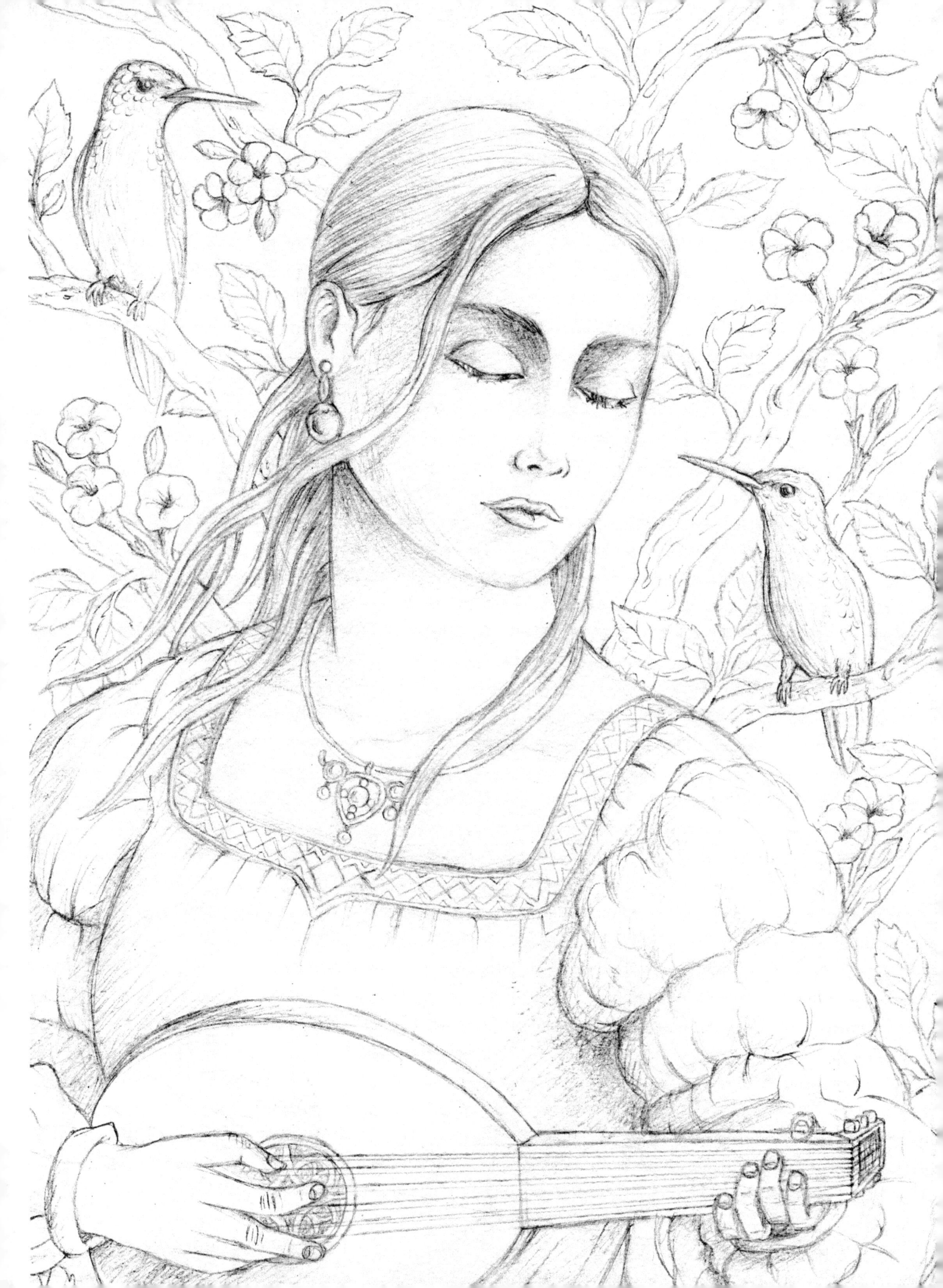

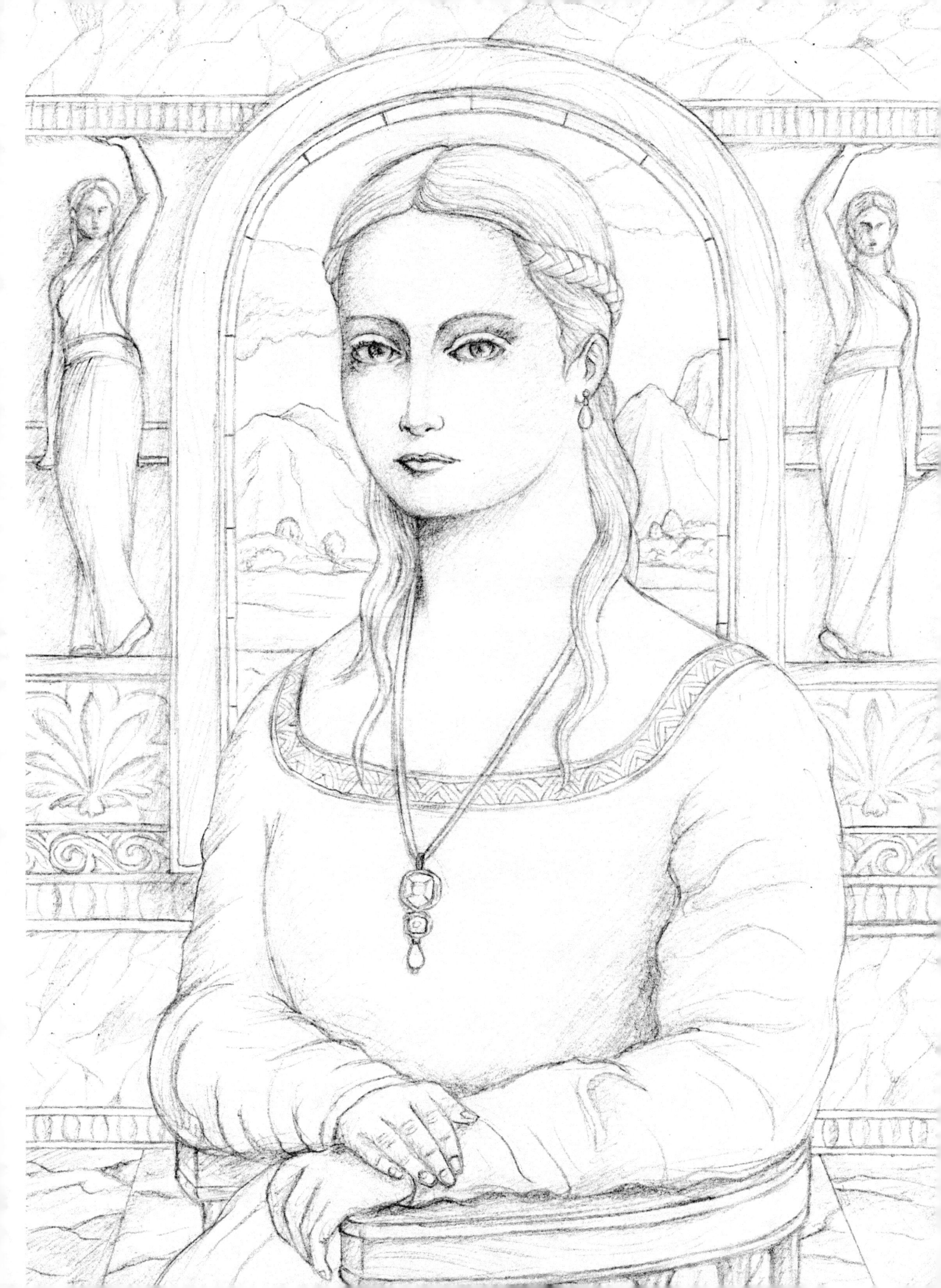

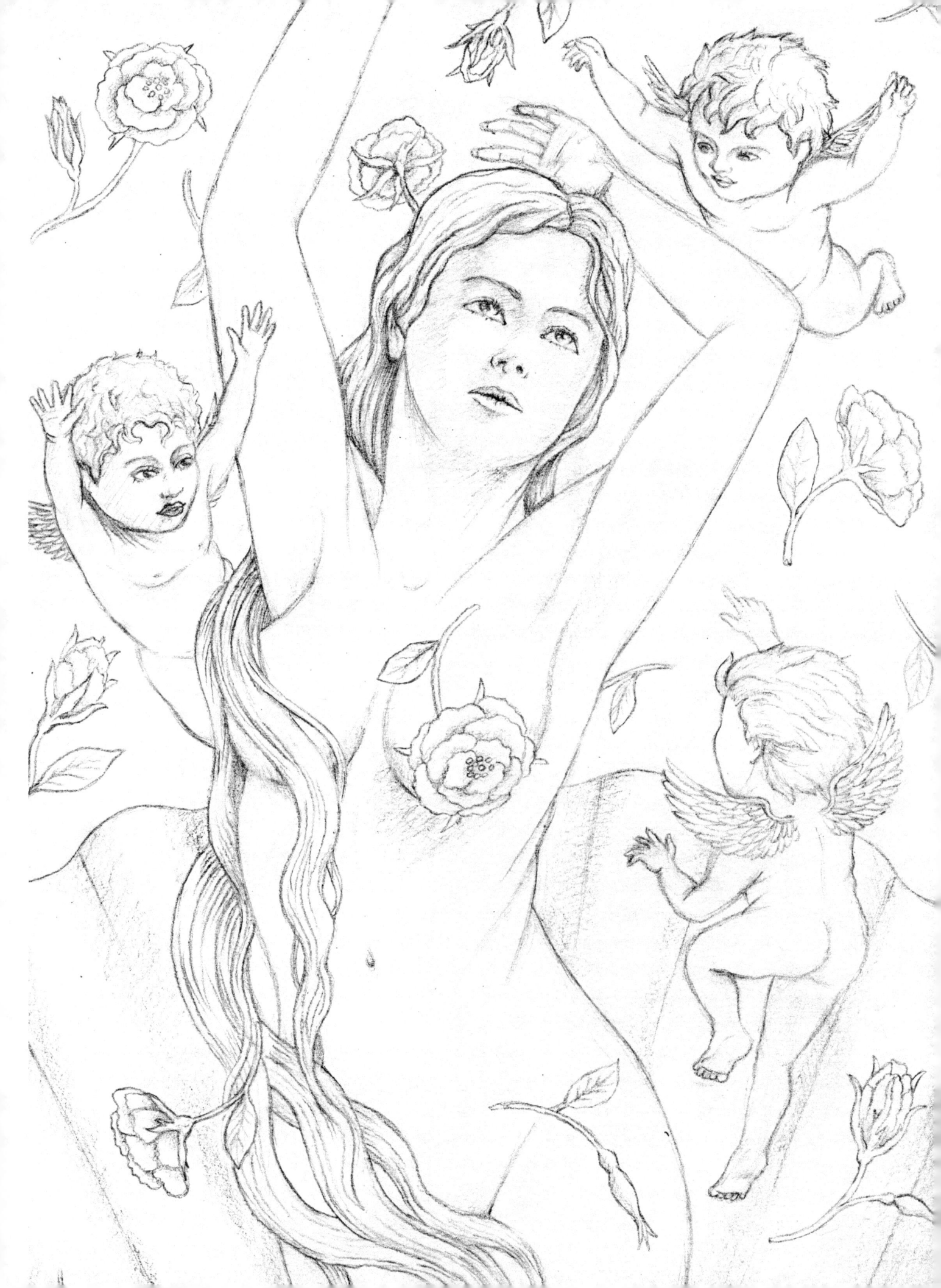

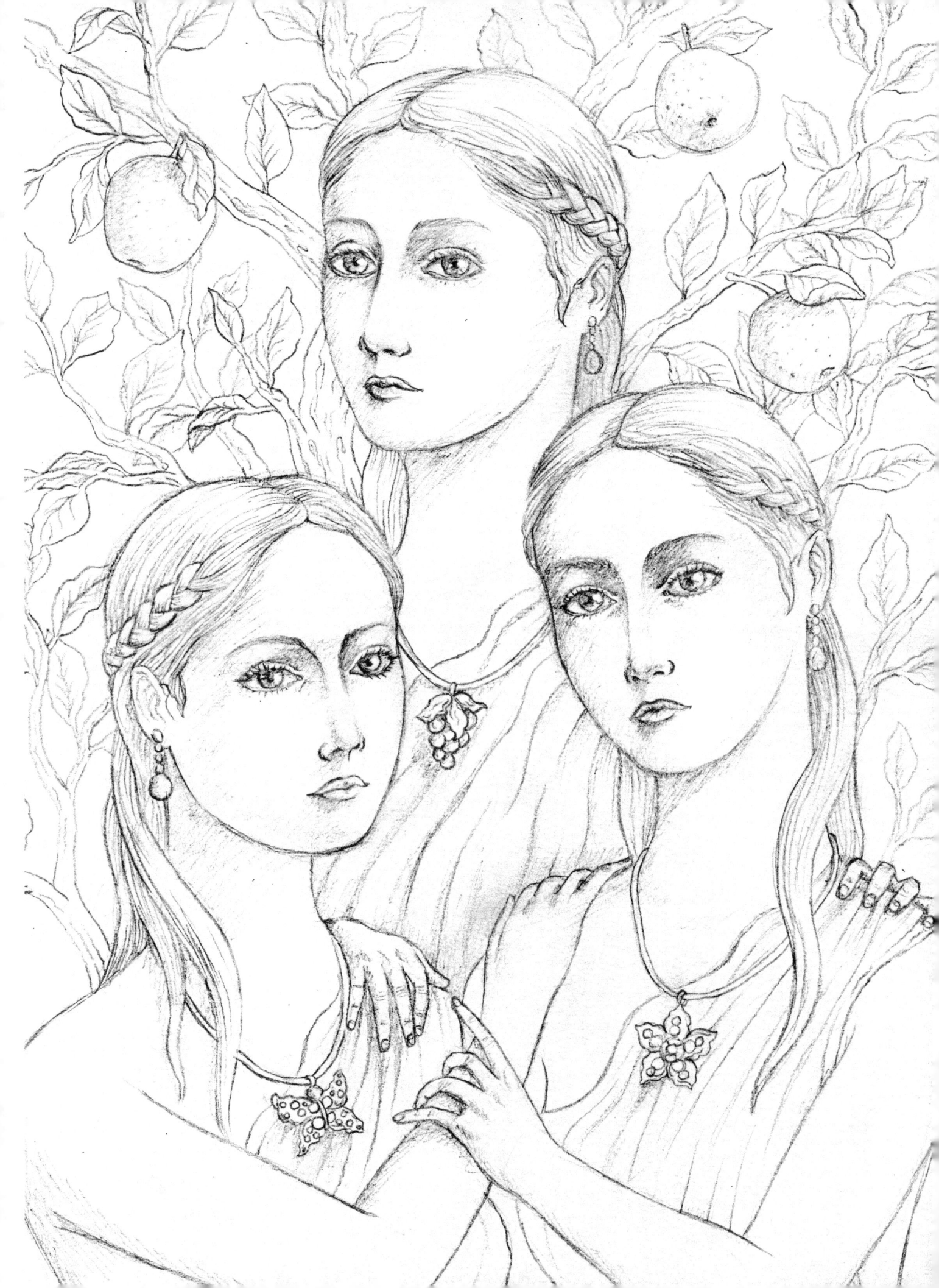

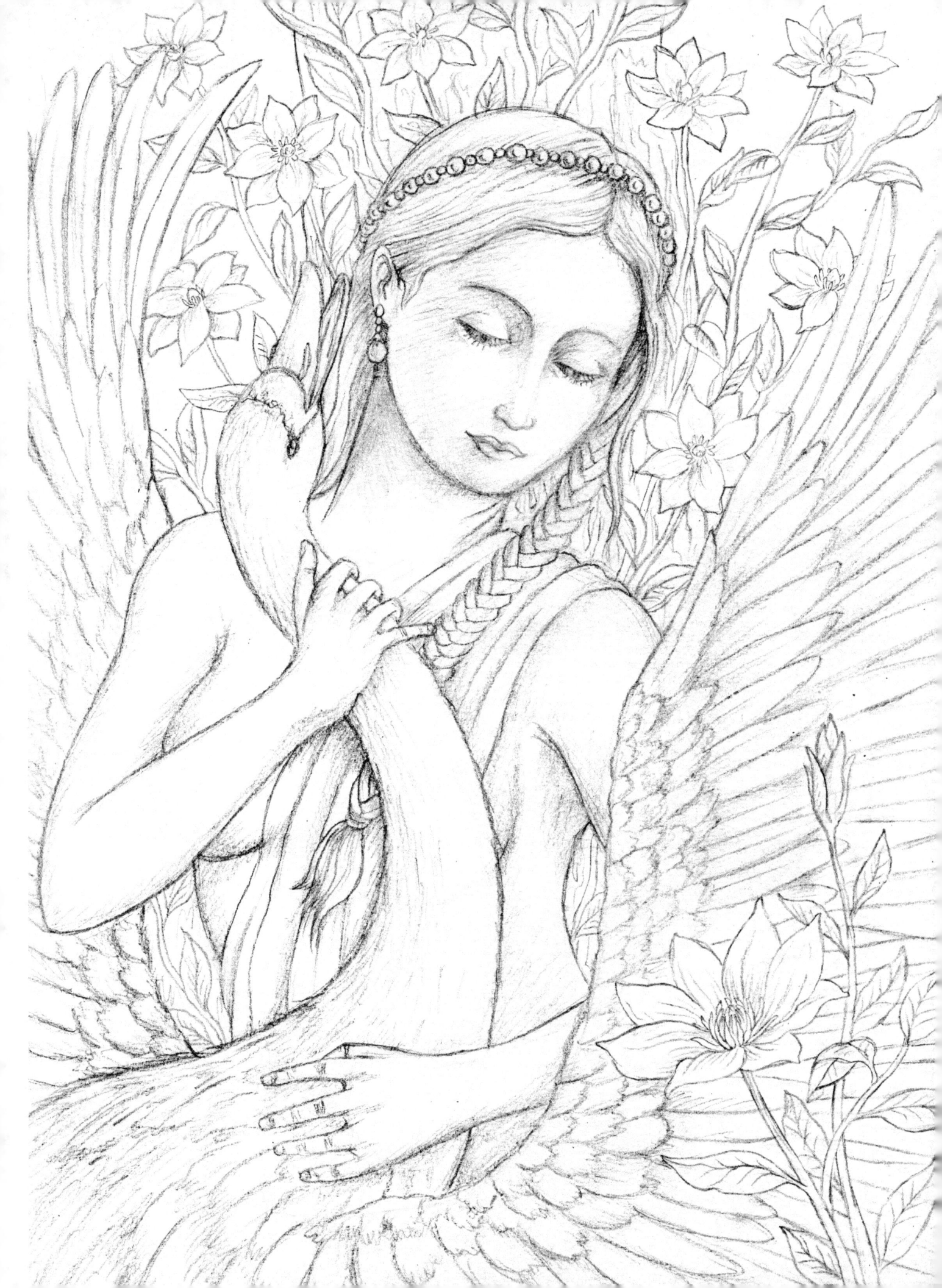

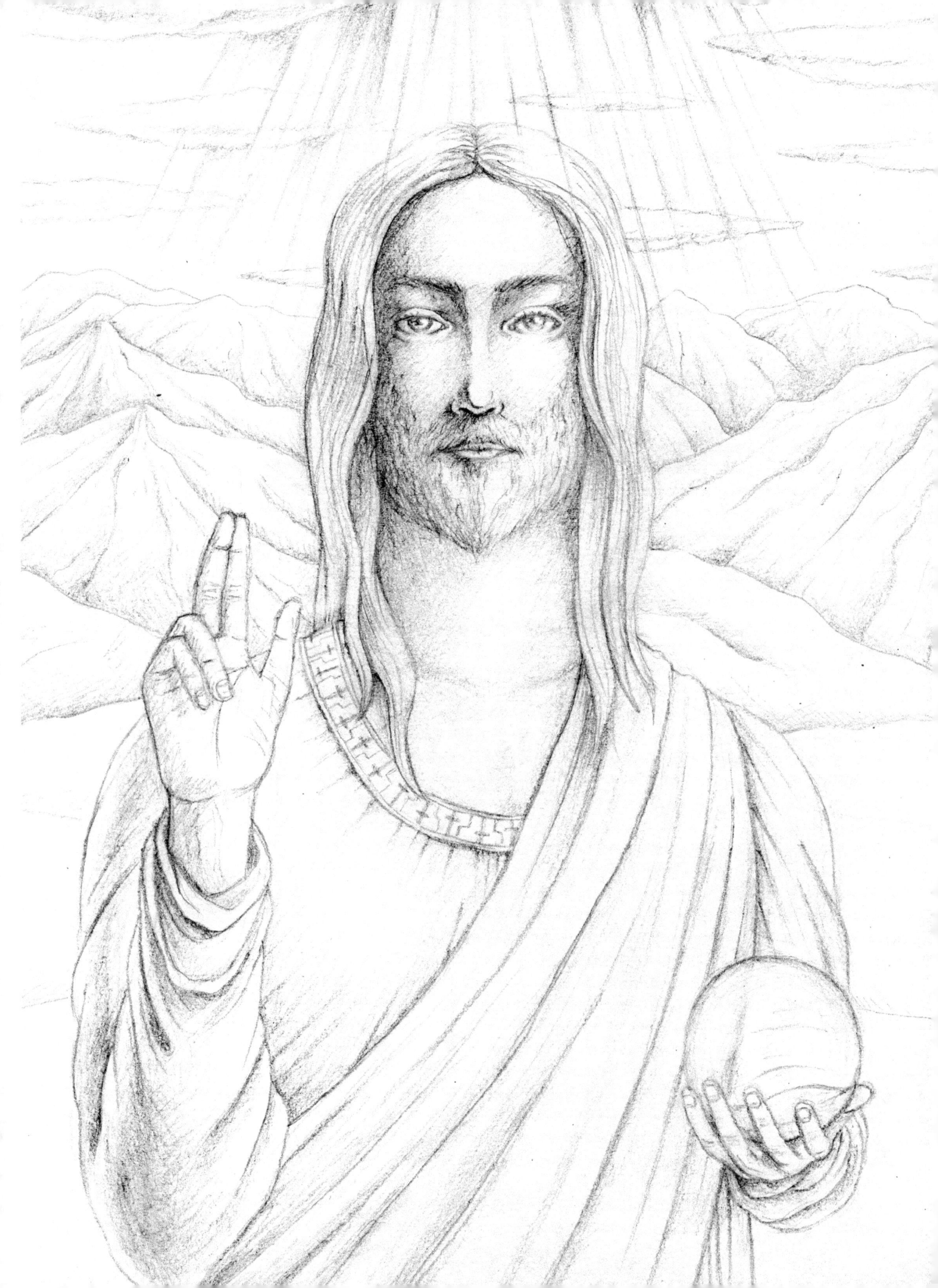

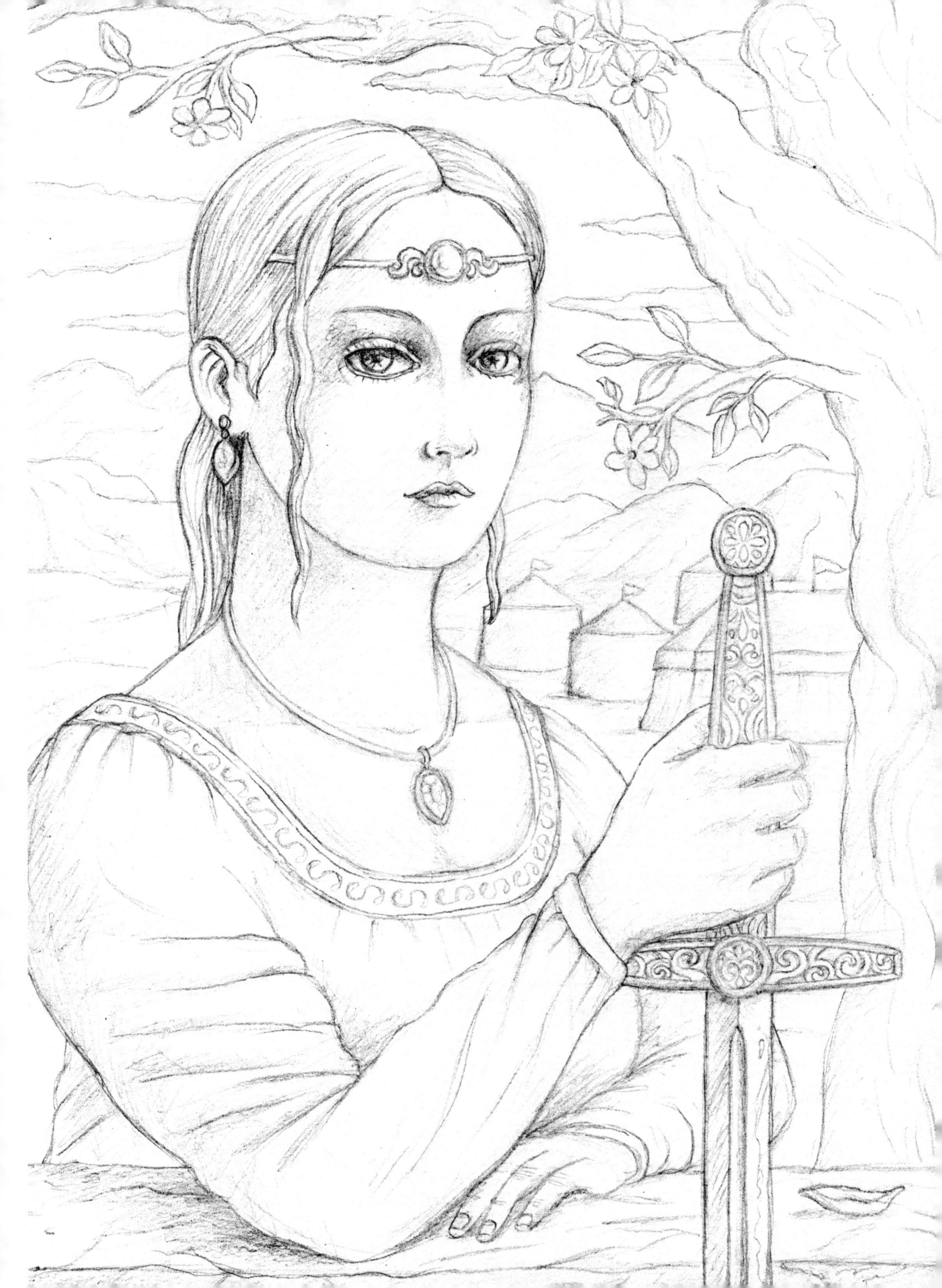

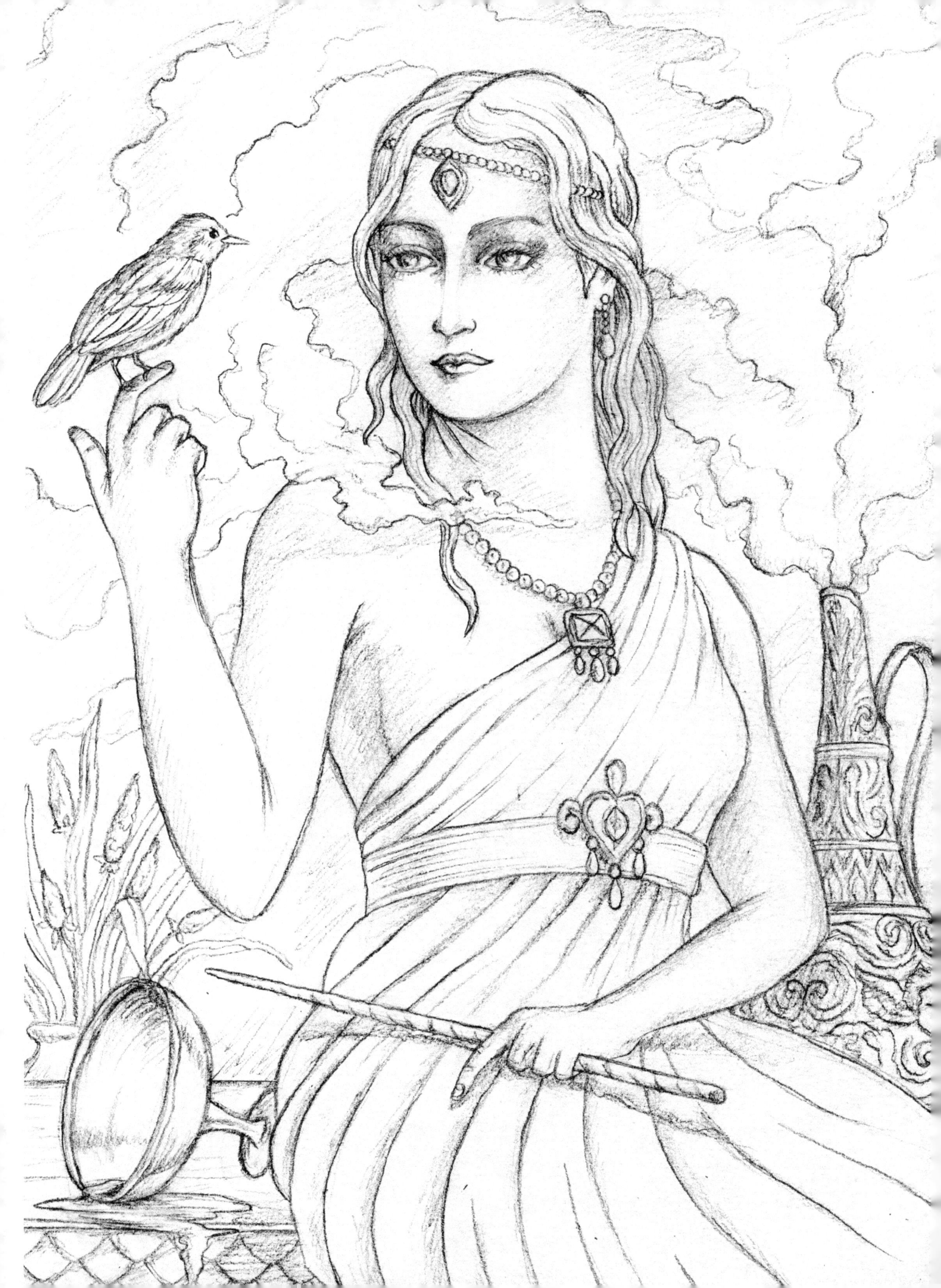

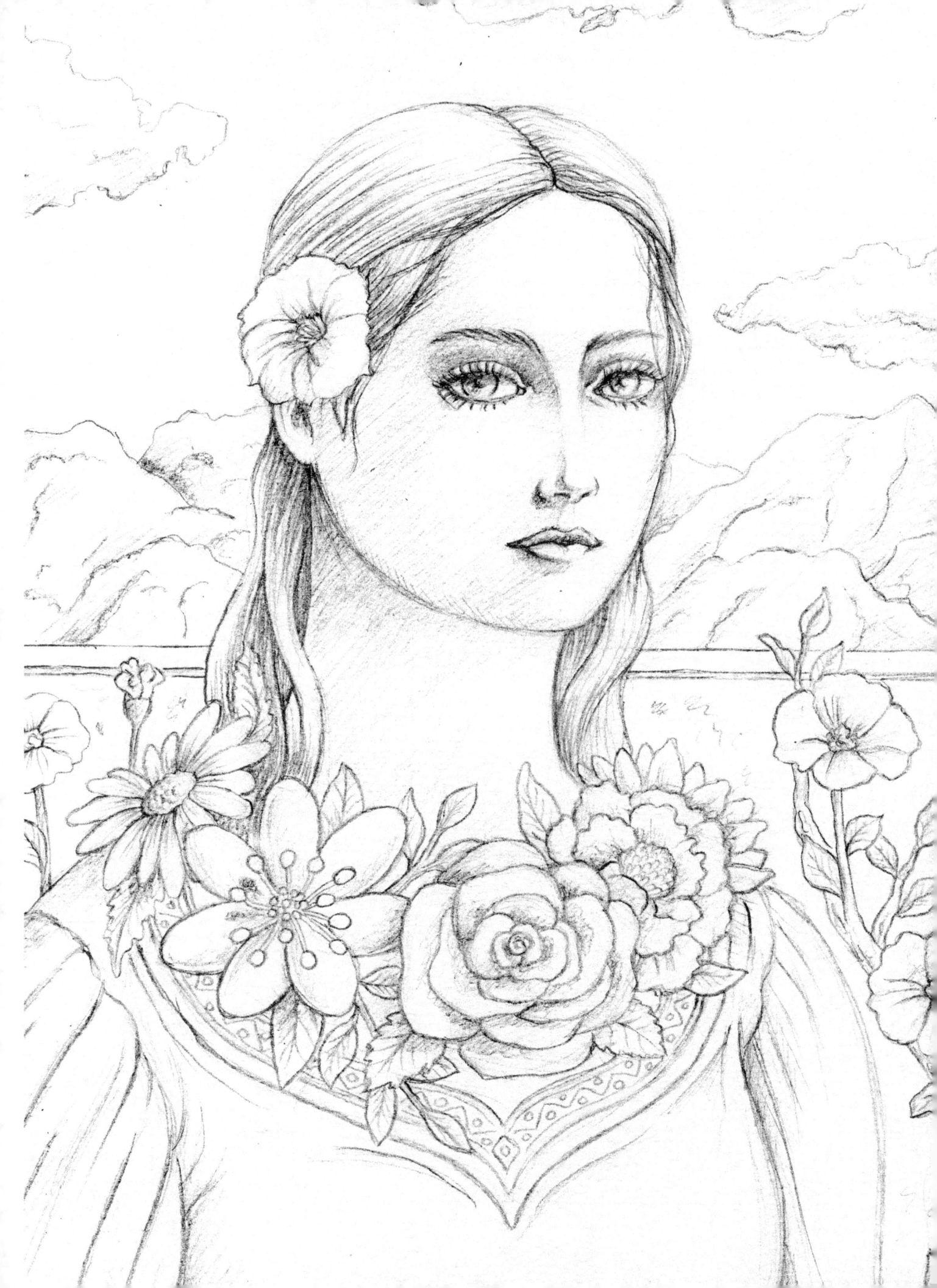

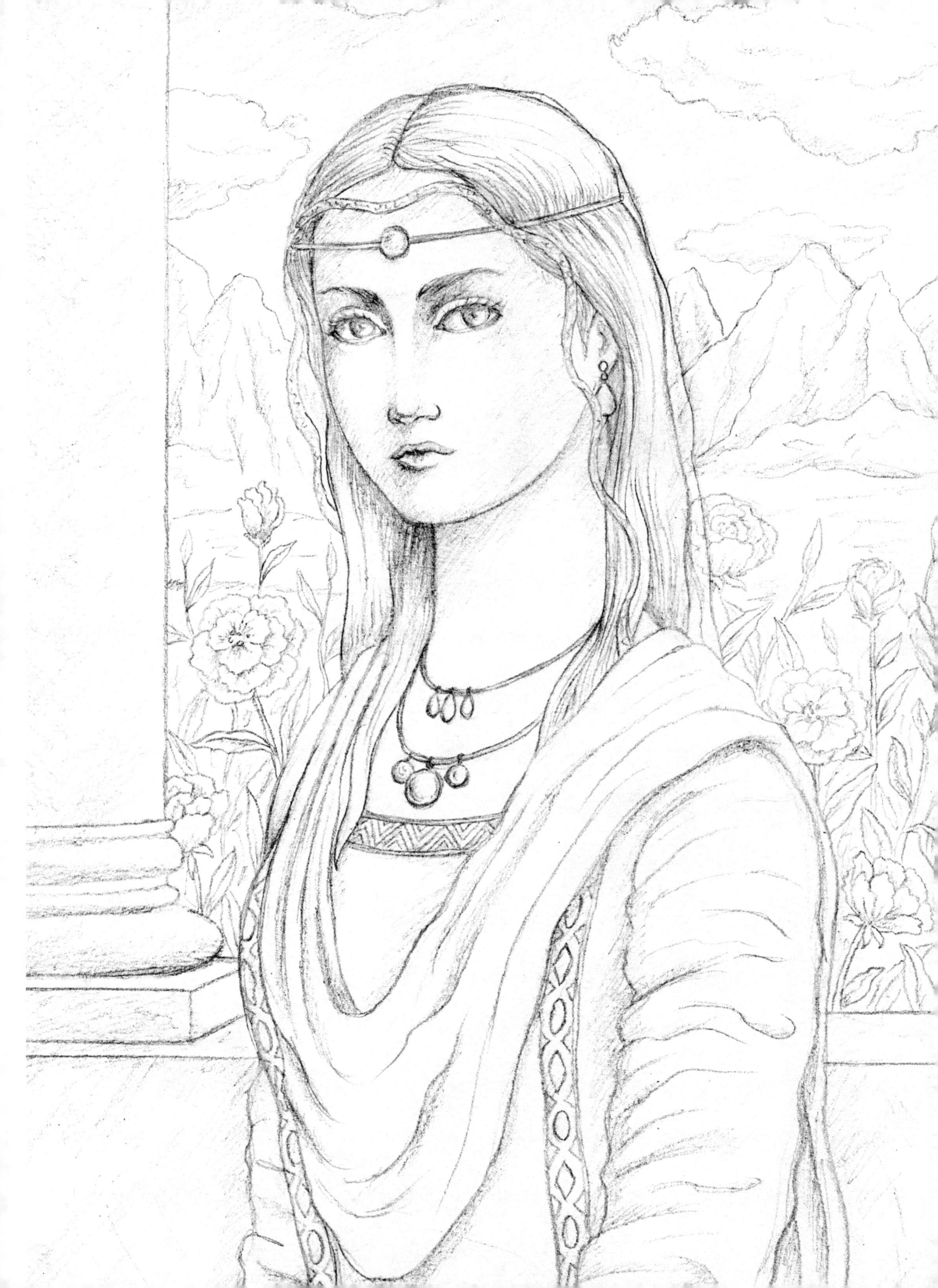

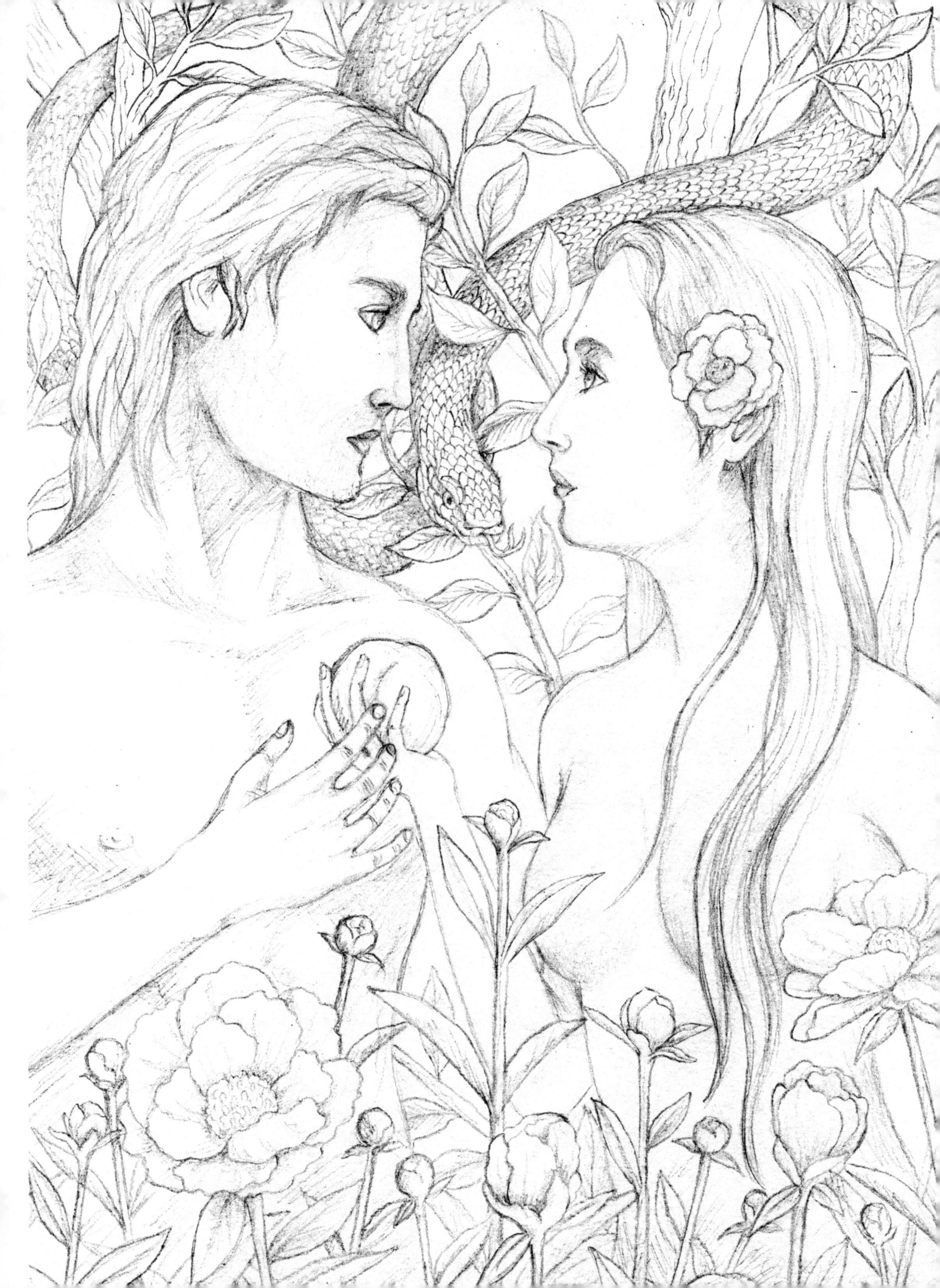

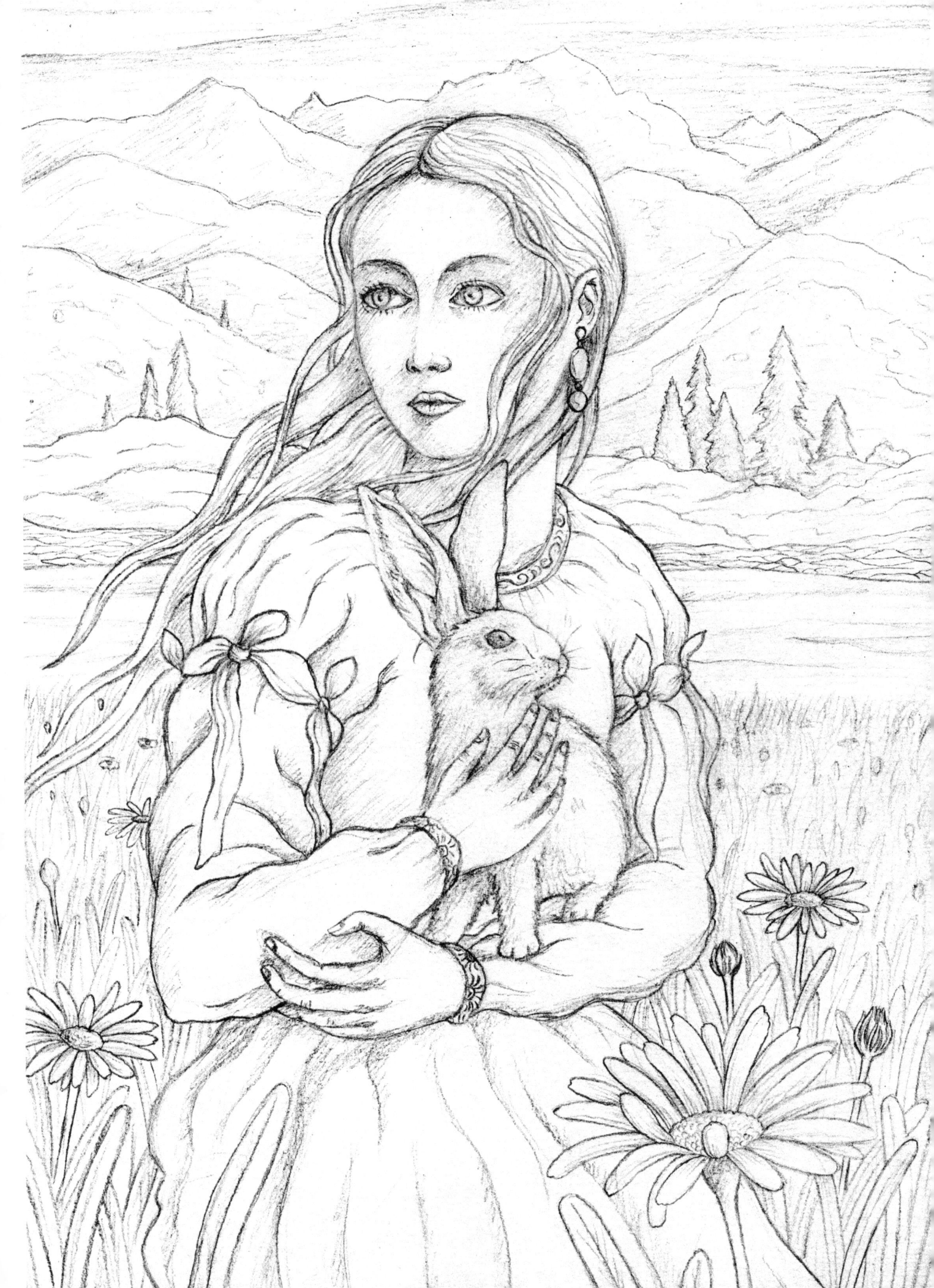

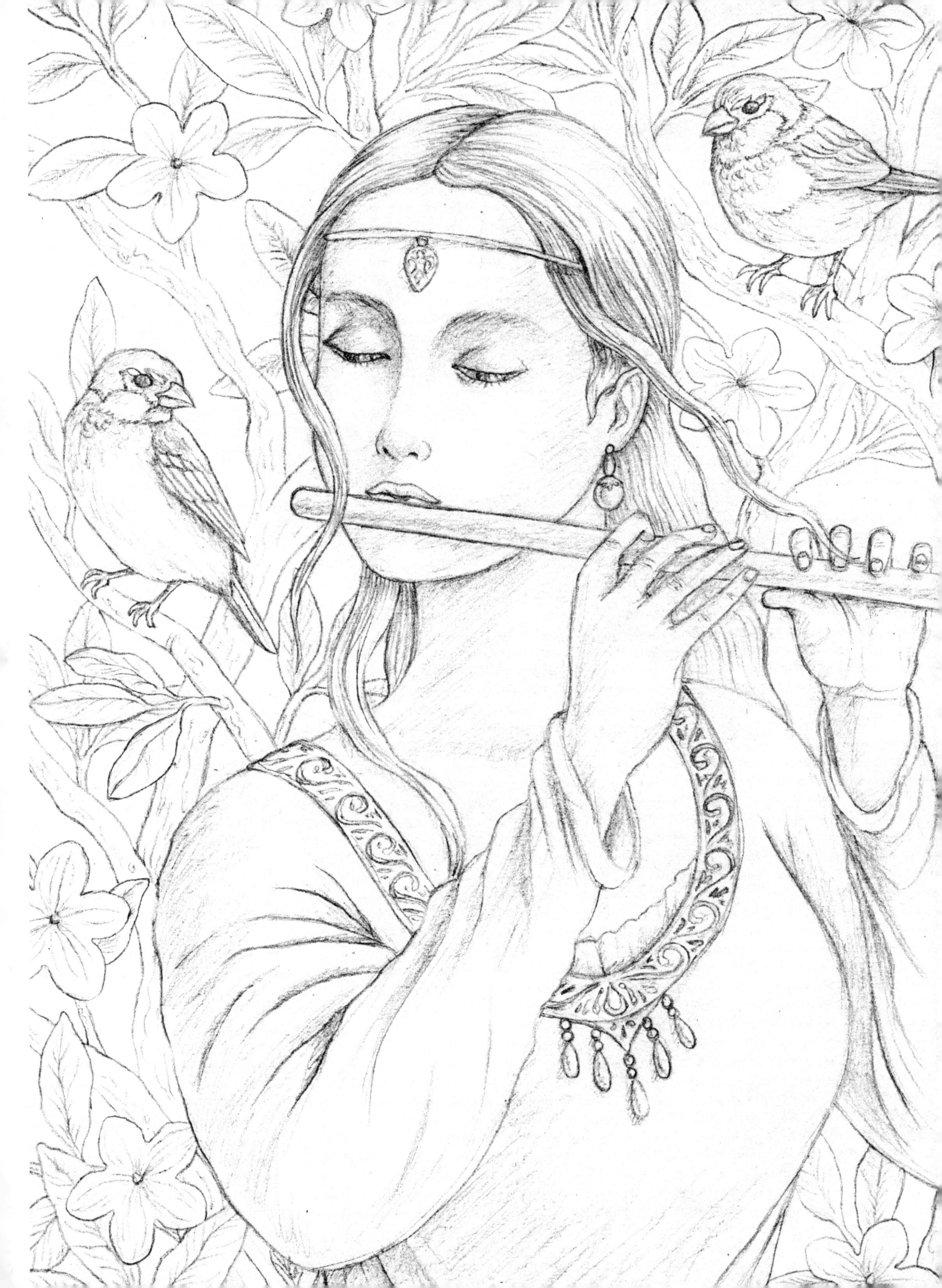

ALSO AVAILABLE FROM VIVID PUBLISHERS

August Reverie

August Reverie 2: Epic

Saga: Fire & Water

August Reverie 3: Expressions

Wild Fantasm

Gods & Goddesses

Preview all the pages at www.vividpublishers.com/books

www.ingramcontent.com/pod-product-compliance
Lightning Source LLC
Chambersburg PA
CBHW080834170526
45158CB00009B/2565